Creative

CALLIGRAPHY

CALLIGRAPHY

Rachel Yallop

Headway · Hodder & Stoughton

Acknowledgements

Rosemary Sassoon, for all her advice and encouragement in the planning of this book.

Miriam Stribley, who first taught me calligraphy at Ravensbourne College of Art & Design.

British Library Cataloguing in Publication Data

Yallop, Rachel
 Creative Calligraphy
 I. Title
 745.6

 ISBN 0-340-58741-5

First published 1993
Impression number 10 9 8 7 6 5 4 3 2 1
Year 1998 1997 1996 1995 1994 1993

Typeset by Litho Link Limited, Welshpool, Powys, Wales.
Printed in Great Britain for the educational publishing division of Hodder & Stoughton Ltd, Mill Road, Dunton Green, Sevenoaks, Kent by Cambus Litho

The author and publishers would like to thank the following for their permission to reproduce copyright photographs: British Library – pp18, 20 Trustees of British Museum – p52 Trustees of Victoria & Albert – p24 and the following for their permission to reproduce calligraphic examples: Cinamon & Kitzinger, Colour Library Books, Elida Gibbs, Nucleus Design

Contents

Introduction

The word calligraphy comes from two Greek words, meaning 'beautiful letters'. Beautiful means whatever you want it to mean, not just perfect letters. This book opens up the whole world of letterforms for you. It has all you need to know to start off, and then gives you lots of ideas about how to use your newly found skill with letters. You are given choices throughout the book from what to write with – anything from a lolly stick to a broad-edged nib, to what kind of letters – from your own original inventions to classic models.

You can start by making your own handwritten letters exciting and startling – this is explained on page 32. Once you have got the idea, you can decorate your own stationery, or design a quick card or wrapping paper.

You and your friends are not all alike. When it comes to lettering, some of you will want to do your own thing, while others might like a model to copy from. For that matter, you yourself are sometimes in one mood and sometimes in another. Your letters will show how you feel at any particular time, and reflect what a particular word or saying means to you. This can be serious, it can be fun, it can be neat or it can be wild.

Where more formal models are shown in this book, all the details are included if you want to do things professionally. The choice is there too. You don't have to start with the first alphabet in the book and work your way through them all in turn. It is a much better idea to have a quick look through them all and start with the one that you like best. If you want your letters to look like the models you will first need

to draw yourself some guidelines. You will also need to be careful with the angle of the pen. It is a good idea to practise with double pencils first, unless you have a calligraphy set. If your own lettering is not exactly like the model, don't worry. You will soon learn to get the pen to do what you want.

Don't be put off if you are left-handed. You may find it just as easy as your right-handed friends. There are special pens for left-handers, but if you still find it difficult to keep the pen at the correct angle for some of the models, then you can always start with the one that many left-handers find easiest – see pages 10 and 18.

Any brush can make wonderful letters. Don't think that you need to spend a lot of money – one brush will do most things for you – and if you haven't got a brush or any nibs handy then use whatever is lying around the house or garden. After all, that's how it all started. Early writers used whatever materials were nearby. Clay, papyrus, or animal skins were used long before we had paper. Slates, wood and even wax tablets have been written on at different times in history. Throughout history people have sharpened reeds, feathers, sticks, bones or whatever was convenient, and made ink out of unusual mixtures – ground up natural pigments, and even octopus ink. So do experiment to make your informal calligraphy really original.

There is a more serious side to all this. An early interest in letters can lead to an interest for life, and could lead to an exciting career. You will see examples of Rachel's professional work throughout the book. Her interest in calligraphy started as a child. The purpose of this book is to encourage you to relax and enjoy creating letters. The choice is yours to express your own ideas through letters in the same way that you do through words or drawings. If there are any words or phrases that you don't understand in the book, turn to the glossary at the back.

Rosemary Sassoon

Tools

Before you begin experimenting with calligraphy, you must collect together some basic tools. You don't need to spend a lot of money and you'll probably find many useful tools around your house. You can write with anything, even a twig from a tree! Letters can look very different when written with different sorts of pens. The marks made can be fine, bold, scratchy, smooth or splodgy. Let's look at some of these tools and the marks they make.

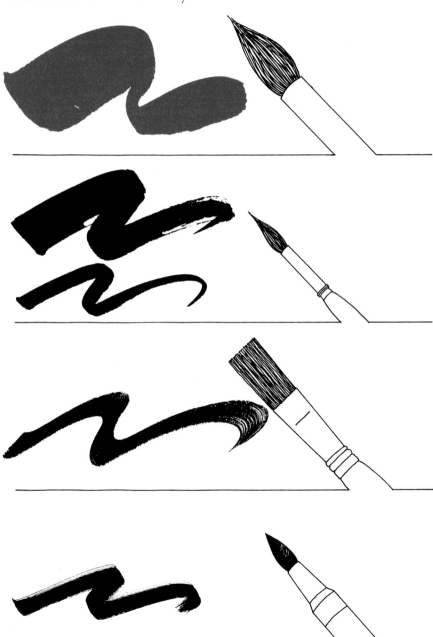

Chinese brush

Paint brush

Flat brush

Brush-line felt pen

Double felt pen

Calligraphy felt pen

Double pencils

Lolly stick, cut to form a straight
edge

Steel nib calligraphy pen

Calligraphy fountain pen

Before you begin

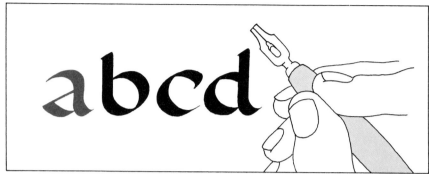

Before you start, make sure that you're sitting comfortably at a table or board. Rest the pen on your middle finger and grip it lightly between your thumb and forefinger.

If you are left-handed . . .

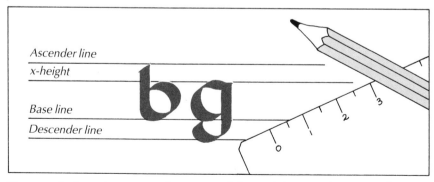

Calligraphy is more difficult if you're left-handed, because everything seems to be the wrong way round! It may help to use a slanted nib and to turn your paper at an angle. Try copying the Uncial letters shown here.

Ruling lines

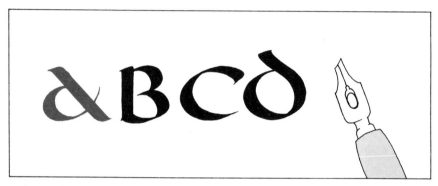

You can help to keep your letters straight and the spacing even, by ruling some lines like those shown above. Look at the letter height diagram for the script you have chosen so you can draw them correctly.

Using double pencils

Before you start using a pen and ink, try writing with two pencils wrapped together with tape.

Dipping your pen

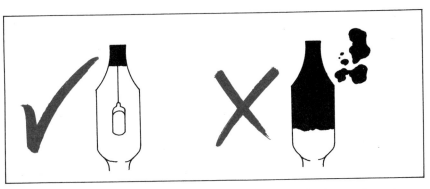

Too much ink in your pen will make your letters splodgy and unclear. Dip the nib just a little way into the ink.

Letter spacing

A simple rule for letter spacing is that the spaces *between* letters should look about the same as the spaces *within* letters. When it comes to the spaces between words, you should leave a gap of about the same size as the 'n' in the alphabet you are using. Keep even letter strokes by holding your pen at a constant angle.

A look at paper and ink

You can use any sort of paper for calligraphy. Most are available from any art shop. Layout paper is not expensive and is ideal for rough ideas. It's slightly transparent so you can also use it for tracing. Try writing on a heavily textured watercolour paper. The letter will look very different from those written on smooth surfaced paper. Experiment with different textures for a variety of interesting effects.

You can buy special calligraphy ink, but simple fountain-pen ink is easy to use and is ideal for trying out ideas. It is fairly watery, flows easily and is washable. Avoid Indian waterproof drawing ink as it's thick, clogs nibs and can be difficult to handle. Coloured inks are fun to experiment with. Try dipping your pen in alternate colours and add a little water. Where the letters touch each other, the colours will blend together for a colourful, marbled effect.

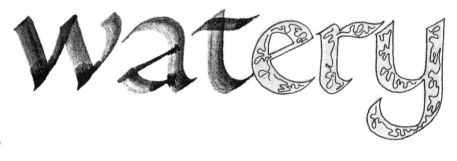

This watery effect was made by dipping the nib alternately in ink and water. You may need to experiment a little until you feel happy with this technique.

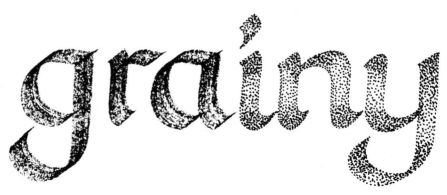

A grainy texture can be produced using a flat brush on a rough watercolour paper.

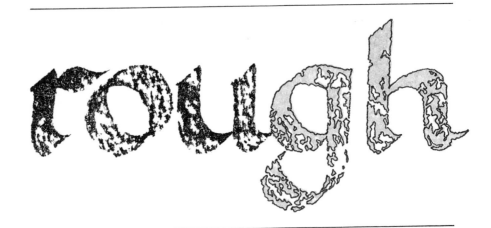

These letters were written on a shiny coated paper with a very smooth surface.

This very textured effect was made by using a steel nib pen on a rough watercolour paper.

Splodgy letters can be produced by writing on newsprint or other porous paper which allows the ink to spread or **bleed**.

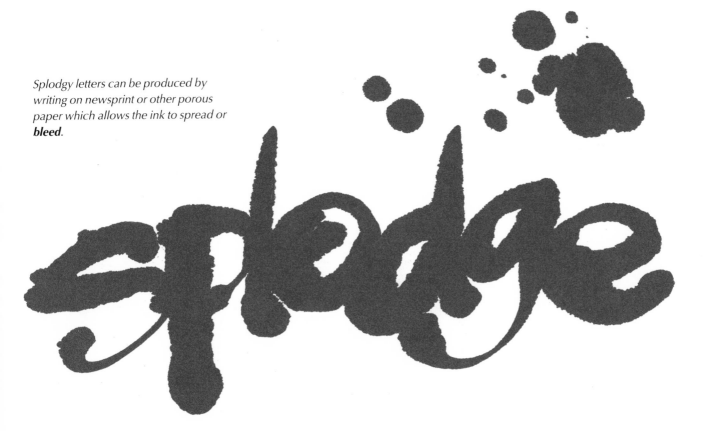

Getting started

Drawing simple patterns is a good way to get started. Patterns help you practise even spacing, constant height, and width of stroke. These things may look easy, but they are actually quite difficult to do without a lot of practice.

Try drawing the patterns shown here, or make up some of your own. They are fun to do and you can use them to form borders round a page, or to make an exciting **collage** of shapes.

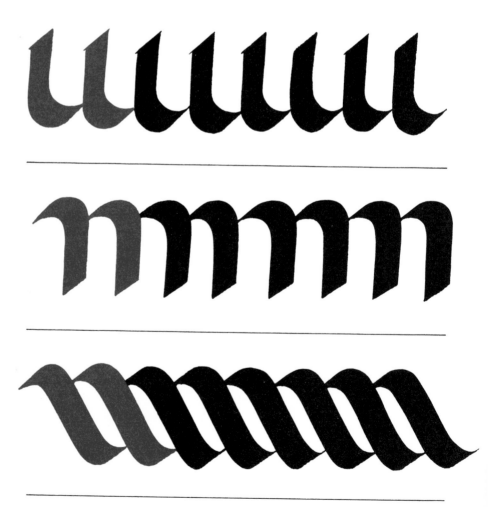

Loosening up

The patterns on the previous page were quite formal and evenly spaced. Informal patterns can also look good. Look at all the interesting shapes created by the swirling lines in the pattern at the bottom of this page. It was drawn very quickly. You can use exercises like this to loosen up your hand and arm.

You can practise your own handwriting to help you loosen up. Try writing an alphabet at a normal speed and then, in two or three stages, write it more and more quickly. Look at the examples opposite and see how the letters take on different shapes and how the spaces in between change.

This free pattern was used in an animated title for a television programme about the modern composer, Sir Harrison Birtwistle.

abcdefghijk

abcdefghijklm

abcdefghijklm

Uncial

There are many different types of letters that you can use in calligraphy. In the 5th-8th centuries scribes used a style of writing called Uncial. They were developed from Roman capitals because their curving shapes were quicker to write. Uncial is one style that is good to use for anything you want to give a historic look.

Uncial letters have no separate capitals and there are different ways of writing some of the letters. You can see some examples of the variations below. Follow the arrows and numbers on the opposite page for the correct order and direction of each stroke.

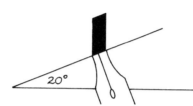

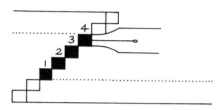

English uncial script from a Bible written in Northumbria before AD 716.

Pen angle
Hold the pen at an angle of 20° for this script. The constant angle will make sure the thick and thins of each letter stroke are in the right places.

Letter height
Mark off four nib widths for the x-height of the letters and rule some guide lines. The ascenders end two nib widths above this line, and the descenders end two nib widths below.

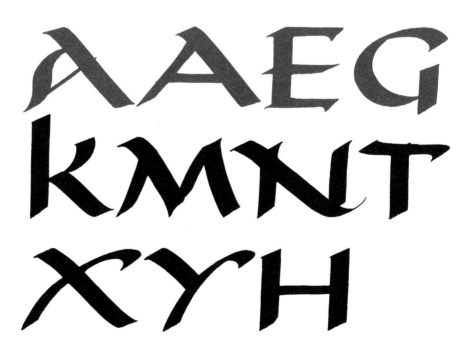

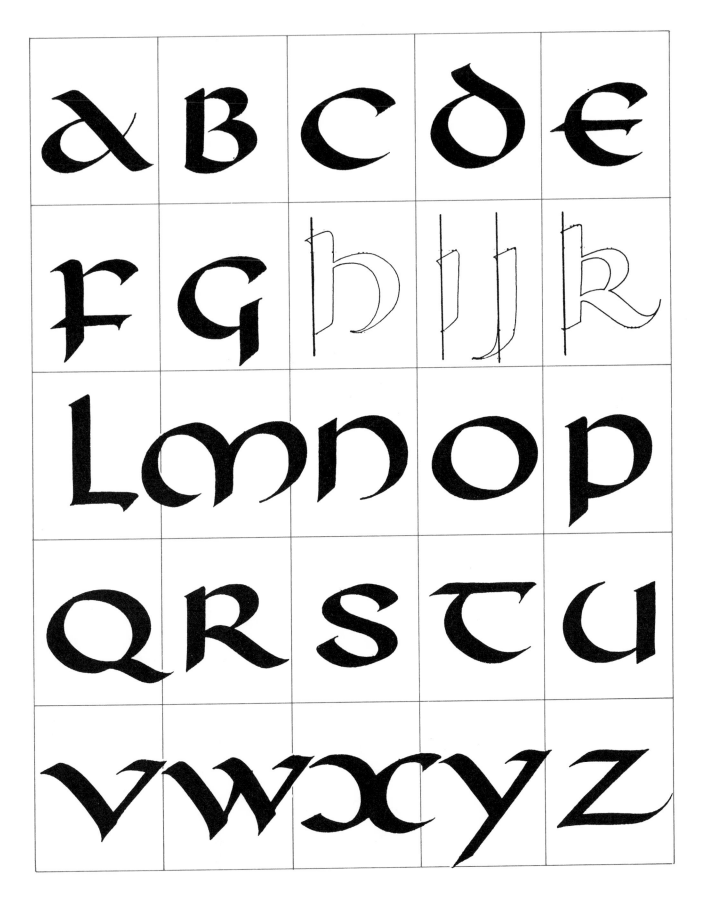

Roundhand

At the end of the 8th century, the Emperor Charlemagne introduced a standard style of writing. This became known as roundhand. Its introduction was the most important event in the history of writing since the Romans adapted the Greek alphabet.

Roundhand has wide and rounded letters based on the 'o'. You should form the letters with bold, natural strokes.

English roundhand, based on 10th century English manuscripts. You can see that the basic structure of letters has not changed in ten centuries!

Pen angle
The pen angle for this script is 30°.

Letter height
There is an x-height of four nib widths and two each for the ascenders and descenders.

ABCDEFG
HIJKLMN
OPQRSTU
VWXYZ

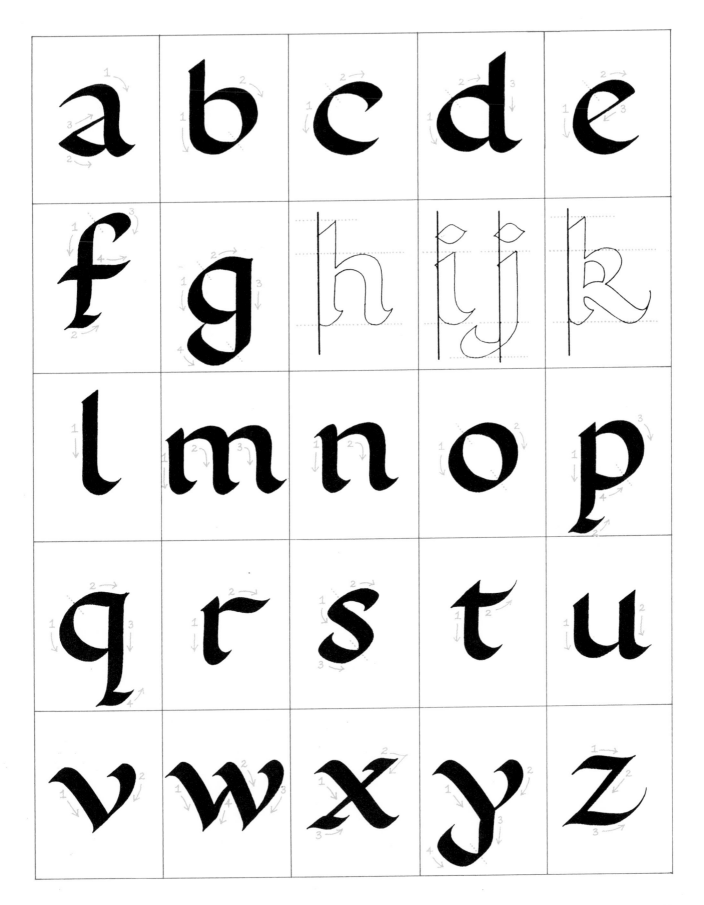

Black letter

During the 11th and 12th centuries in England, France and Germany, people started writing letters that were very tall and thin. This became known as black letter because the letters look dark and heavy.

Black letter writing should be quite closely spaced. The spaces between letters should look about the same as the spaces within the letters. A whole page of black letter writing makes a strong pattern and can often be difficult to read. An example of the capital letters is shown below. They are rather elaborate and best used only as **initials**.

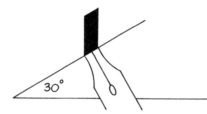

Pen angle
For this script angle your pen at 30°.

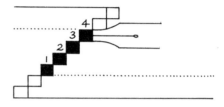

Letter height
There is an x-height of four nibs widths and two each for the ascenders and descenders.

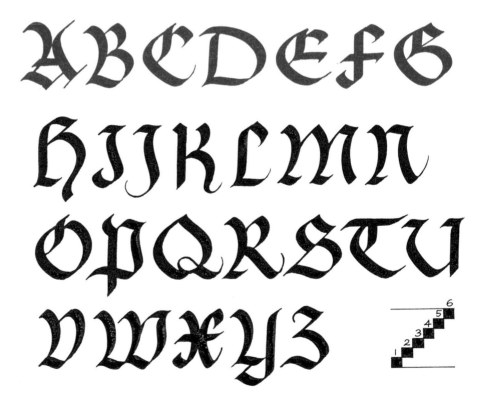

22

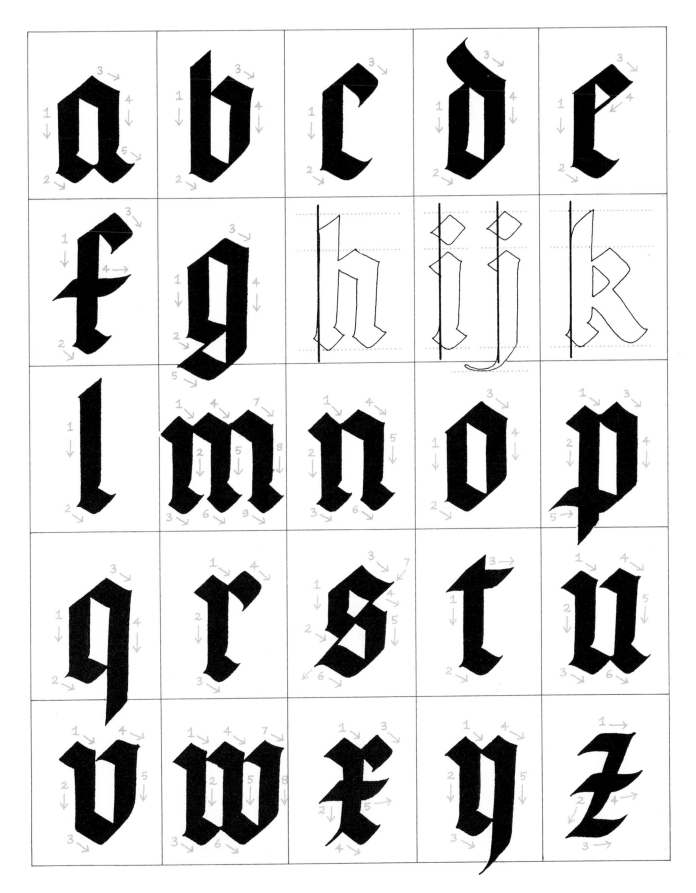

23

Italic

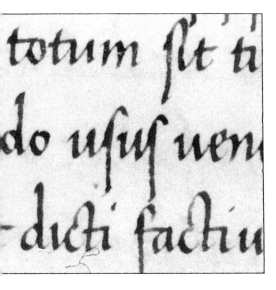

Italic script from a manuscript written in Rome in 1465.

Italic is an attractive calligraphy style. It was developed in 15th century Italy, out of an angular but graceful alphabet designed by the scribe Niccolo Niccoli. It was quick to write and soon became popular.

Italic has tall and oval letters which slope to the right. Draw some slanted, parallel guide lines to help you keep all the letters pointing the same way!

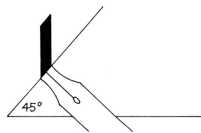

Pen angle
Angle your pen at 45° for this script.

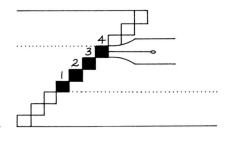

Letter height
There is an x-height of four nib widths and three each for the ascenders and descenders.

ABCDEFG HIJKLMN OPQRSTU VWXYZ

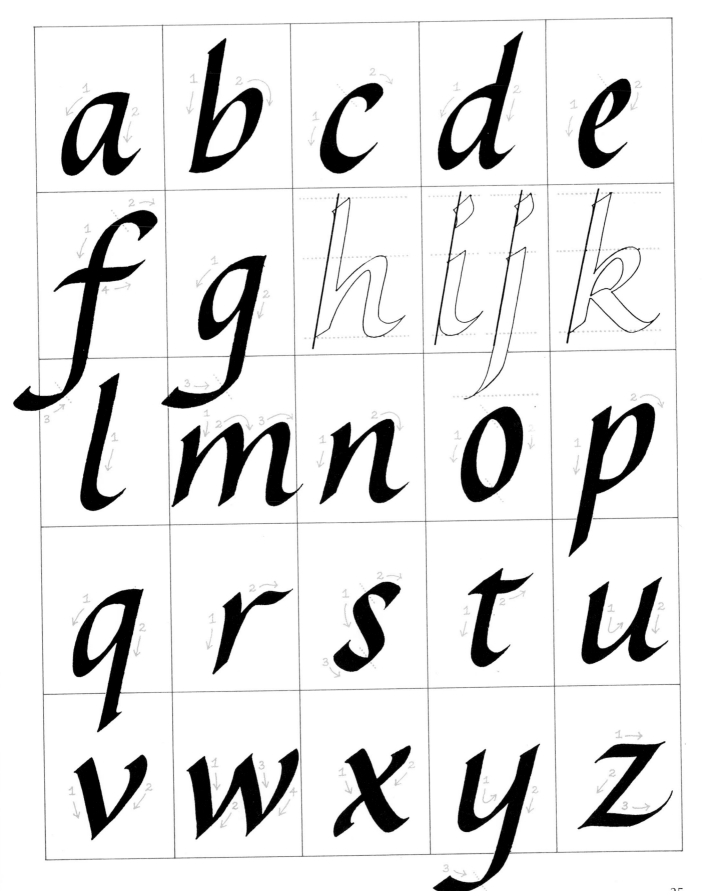

A free italic script

The alphabet opposite is based on the italic script. The letters are graceful, slanted to the right and oval in shape, but they are written with more freedom and speed than traditional italic letters. They look modern, but at the same time they keep the attractive qualities of italic.

Practise the letters on the previous page until you feel confident that you know the basic shapes and structure of italic letters. Now try writing them with more freedom, using a brush-line felt pen. You could make some of the strokes longer, as in the A below. Many of the small letters look good this way too. Look at the x, y and z opposite.

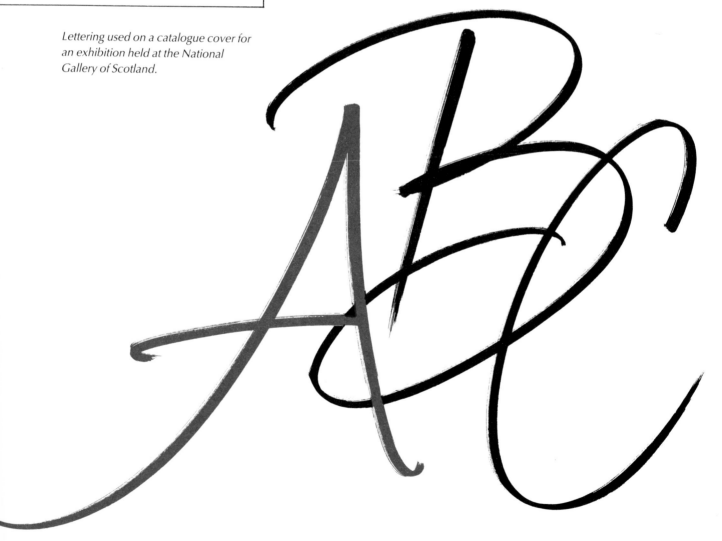

Lettering used on a catalogue cover for an exhibition held at the National Gallery of Scotland.

a b c d e
f g h i j k
l m n o p
q r s t u
v w x y z

A script typeface

This is the Bottoms – Up typeface! A script letterform in bold and medium weights designed to look like handwriting. The original letters were freely written with a brush–line felt pen.

An example of typesetting using this script typeface.

These letters are part of a script typeface designed for a chain of wine shops called 'Bottoms Up'. First the letters were freely written on paper with a brush-line felt pen. Then they were digitized on a computer. This is a method of plotting the outline of each letter to make an electronic alphabet for the computer to work with.

Try designing your own typeface based on your handwriting. It could be used for making signs or for writing your name. Write each letter of the alphabet, then cut them out separately so they can be placed together to form words. You will need to trace or photocopy any letters which occur more than once in a word.

Brush-line felt pen

ABCDEF
GHIJKLM
NOPQRS
TUVWXYZ

a b c d e

f g h i j k

l m n o p

q r s t u

v w x y z

Some more pens . . .

The pens and brushes shown on pages 8 and 9 are ones that you might already have, or which can easily be made. Most of those shown here are more specialised and you may need to go to an art shop to buy them. However, you can make the balsa pens yourself from thin pieces of wood. Cut them to whatever width you like and nick them to make double or more strokes. It is best to wrap a length of sticky tape around the handle part as the ink will seep up the porous wood.

Automatic pen, size 6

Five-line automatic pen

Automatic pen, size 9

Coit pen, size ¼

Balsa wood pen

Split-ended balsa wood pen

Script pen

Experimenting with letters and words

These letters for a book jacket were written quickly and with energy to suggest a lively musical quality.

It's fun to experiment with different tools and styles of letters. Line up all your pens and brushes, together with a pot of ink. Choose any letter of the alphabet and try writing it using each tool in turn. It is best to keep to just one letter at first so that you can easily compare the different effects. Look at the letters shown opposite which were written in this way. Which do you like best? Now try writing different letters until you eventually build up a whole alphabet. Don't worry if some of your letters aren't perfect. Sometimes an accident with the ink or an unusual shape can look very effective.

Next, try writing some words. Look over the page. Each word was written, using an appropriate pen or brush, to express its meaning through the style of the letters used. Try writing these words or think of some of your own. Before you put pen to paper, think what the word means. This will help you create letterforms which suit that word. Have fun, and . . .

. . . remember to

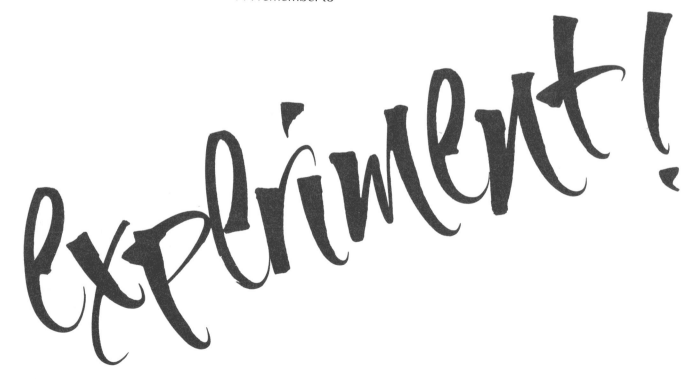

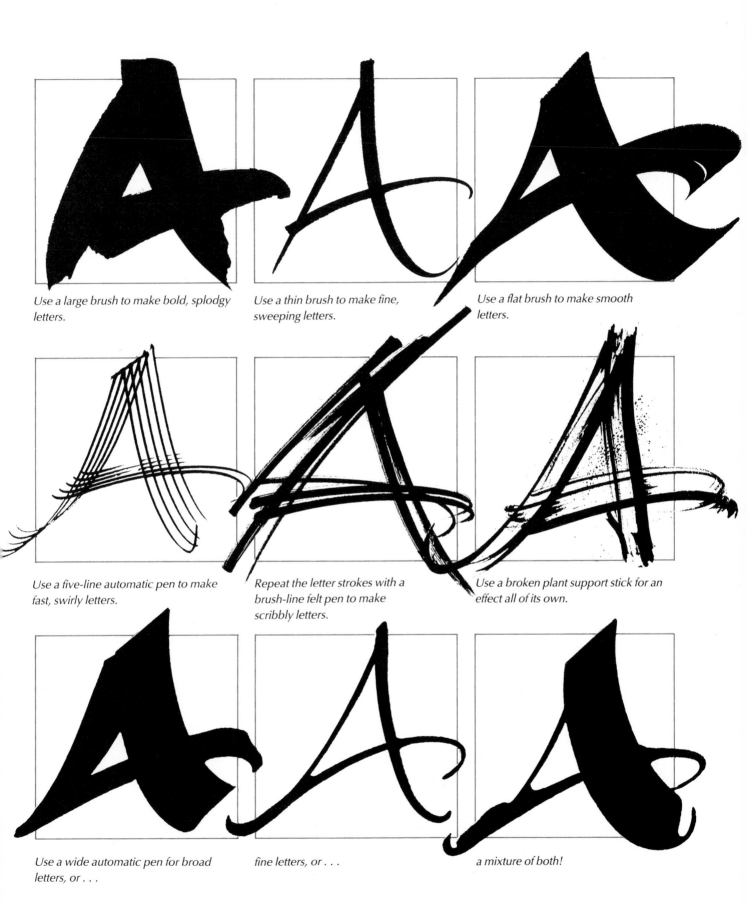

Use a large brush to make bold, splodgy letters.

Use a thin brush to make fine, sweeping letters.

Use a flat brush to make smooth letters.

Use a five-line automatic pen to make fast, swirly letters.

Repeat the letter strokes with a brush-line felt pen to make scribbly letters.

Use a broken plant support stick for an effect all of its own.

Use a wide automatic pen for broad letters, or . . .

fine letters, or . . .

a mixture of both!

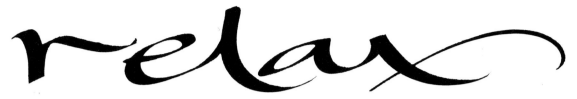

These restful flowing letters were written
with a flat brush, The low x-height and
extended forms add to the feeling
of calm.

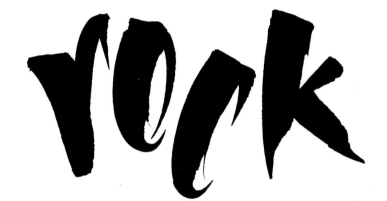

Try writing letters which do not all sit on
a constant base-line. These letters,
placed at different angles, suggest the
rhythm of rock music.

Here, the meaning of the word is
expressed by stretched letters.
The very exaggerated 'e' adds to
the effect.

The 'n' seems to have fallen off the end
of the word!

fast

Writing letters quickly and in a slanted form expresses the feeling of speed.

Poison

These letters have a very poisonous, wicked feel about them! They were written with an automatic pen which was twisted to taper the downstrokes of the letters.

MURDER

This effect of dripping blood was achieved by first writing the word using simple capitals. Then, while the letters were still wet, a clean pen was dragged downwards through the ink.

tall

These letters were greatly condensed to show the word 'tall'. You could do the opposite for 'short'.

Writing letters with a brush

The brush is one of the most versatile tools used in calligraphy. The fine hairs are very flexible and can be twisted in all directions without snagging the paper or splattering ink. Try writing with a brush held upright at right angles to the paper so you use just the tip, or angle it close to the page, pressing down the whole length of the brush.

The large A opposite was written using these two methods together. The words below were all written with the same number 2 sable paint brush! You can achieve this variety of line weight by changing the angle and pressure of the brush. Look at the words shown over the page for some ideas on brush calligraphy.

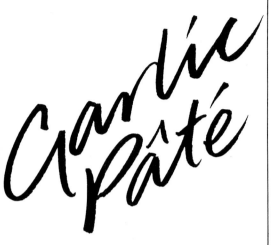

Brush calligraphy used on a pâté label for Somerfield Food Stores.

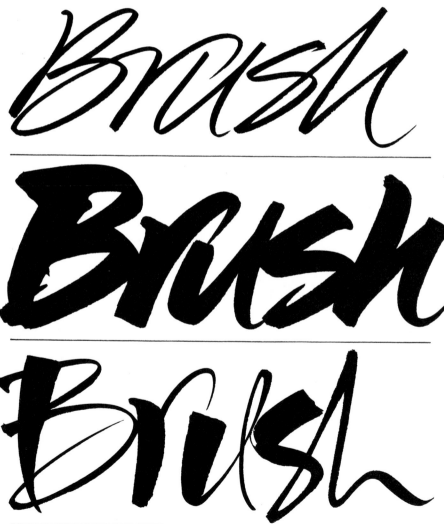

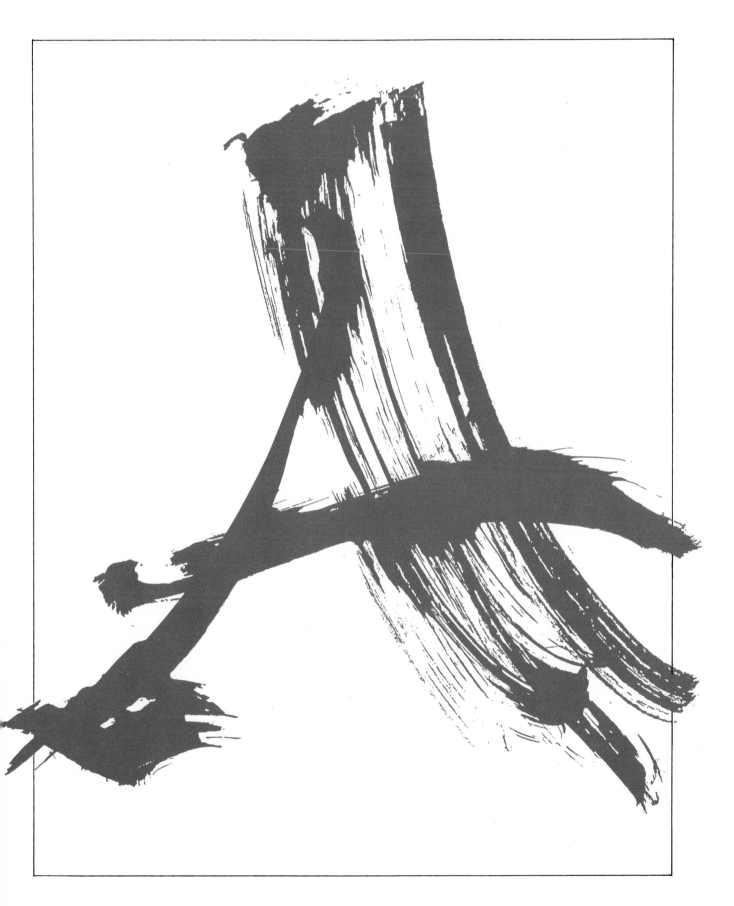

Each stroke of this word was written very quickly. The letters give the effect of rising and falling like a firework.

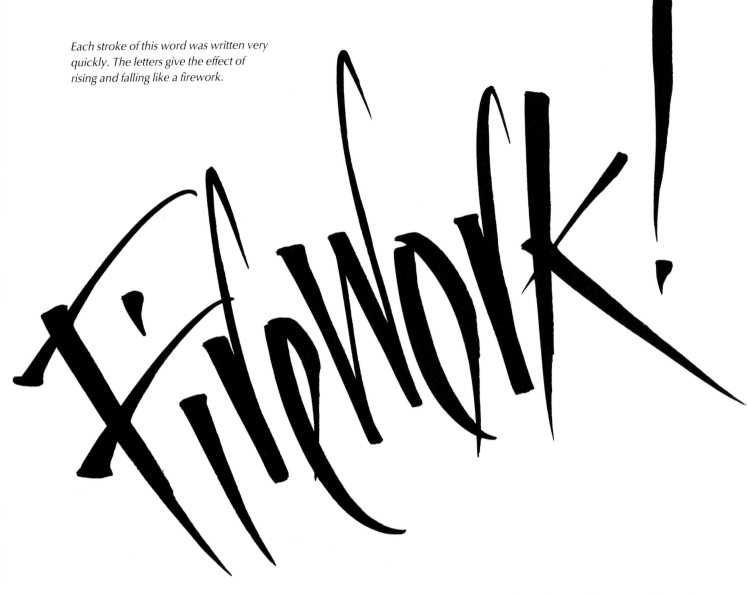

The thickness of the downstrokes and the rhythm and shapes of the letters give this word its wave-like appearance.

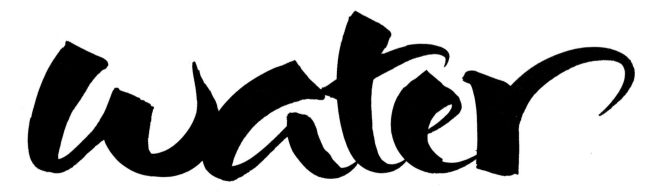

These letters were written with the brush held upright and at right angles to the page. This is a method used by Chinese and Japanese calligraphers.

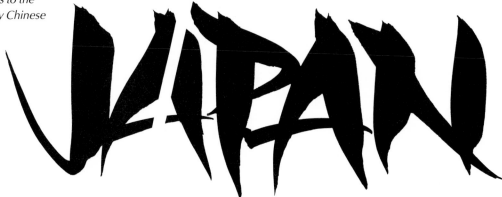

These pointed letters, and the way they fit together, make the strokes look like flames. The effect was achieved by using a flat brush which was twisted to taper the downstrokes of the letters.

This word was written in a loose running script to express the freedom of flying.

Designing a monogram

A monogram is a design of one or more letters, often the initials of a name. They can show simple geometric shapes, especially if you are using straight sided letters, or elaborate curving patterns if they are rounded letters. They are a good way to decorate writing paper. You can also repeat a monogram to form a close pattern or border as in the IM design shown here. It is best to use only two or three initials so you don't have too many letters to worry about.

Have a go at making a monogram out of your own initials. Look carefully at the individual letter shapes to see how they would best fit together. You might make the letters overlap one another, or draw round them, or fill in the spaces within and between each letter.

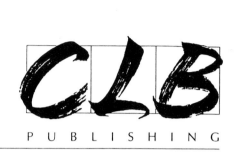

A logotype using a simple monogram of three brush written letters.

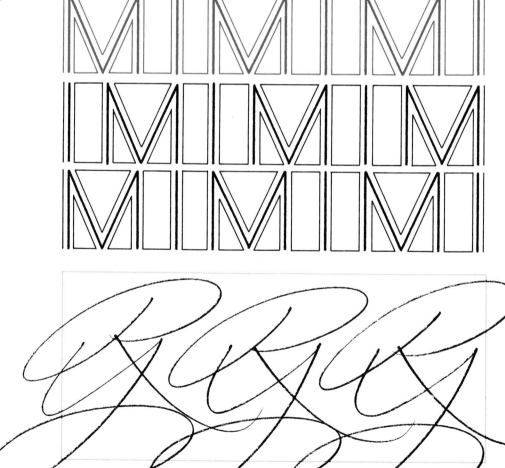

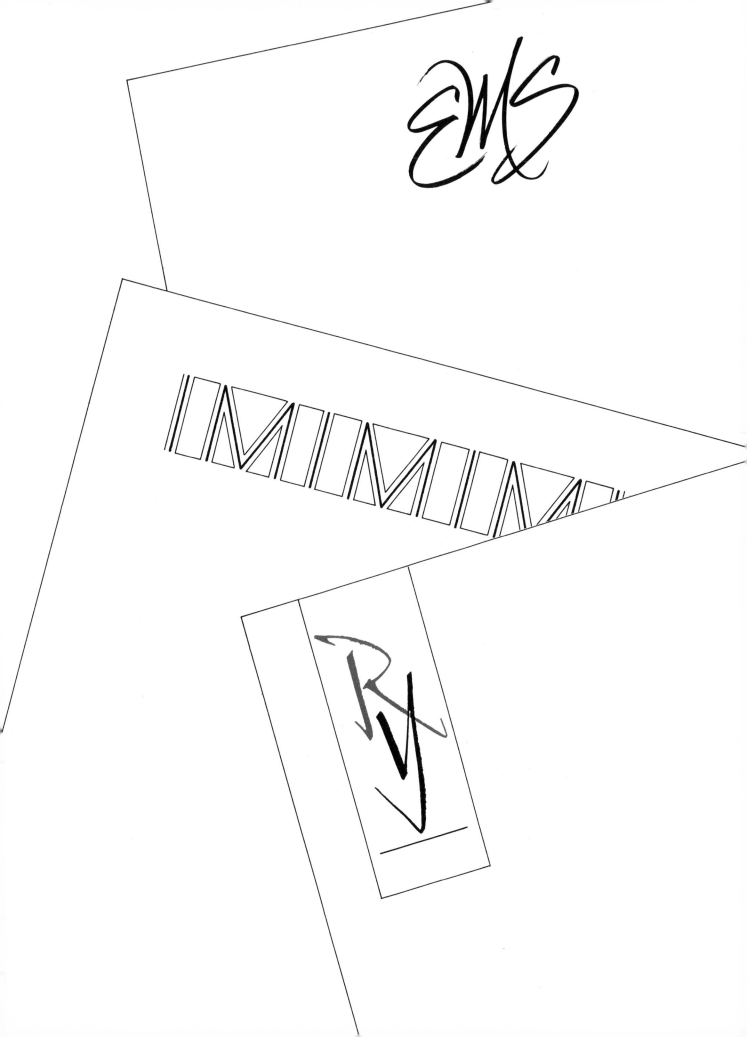

Making wrapping paper

Use your calligraphy skills to make original wrapping paper. The 'happy birthday' paper shown here uses black letter to create a dense pattern of closely spaced letters and lines. You will need to draw guide lines as shown in the drawing below. First write out a couple of lines. Photocopy these several times, paste the copies together to form a repeat pattern, and then copy the whole thing again for the finished sheet.

The 'with love' paper is quicker to do, but you will still need to draw some evenly spaced lines to write on. You can make paper for any occasion by using other greetings, such as 'good luck', 'get well soon', 'happy new year' or 'thank you'. Make a matching gift tag out of card to complete your parcel.

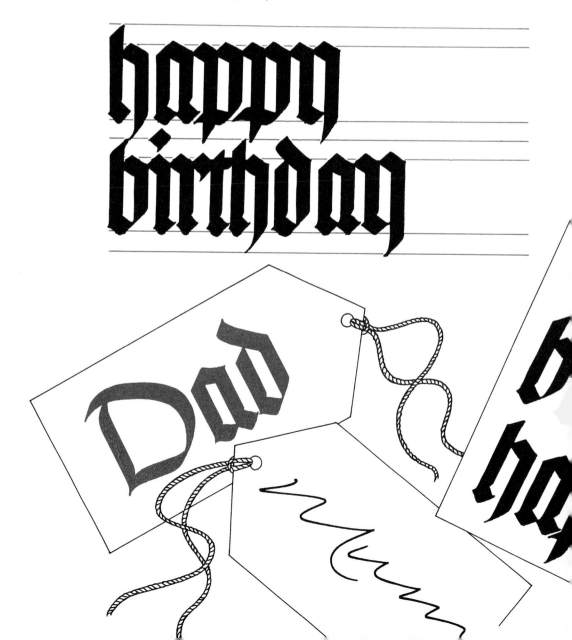

happy happy happy
birthday birthday
birthday happy happy
birthday happy birthday
happy
birthday

happy

birthday

with love ♡ wi
♡ with love ♡
e ♡ with love ♡
♡ with love ♡
e ♡ with love
love ♡ with lo
♡ with lo
love ♡ with
love ♡ with
love ♡ wi
itth love ♡
ith love ♡

Greetings cards and invitations

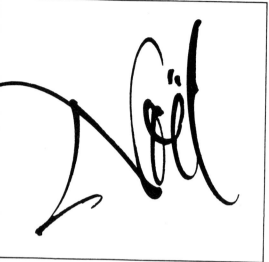

Impress your friends and relations by making them specially designed cards. The cards shown here are simple to do but look original and attractive. The Christmas one, using a variety of styles, is more complicated, but if you practise the different letterforms it will look very effective.

Practise your chosen greeting on layout paper. When you are satisfied with the result, cut it out and stick it onto a piece of folded card. If you are feeling confident, try writing straight onto a prepared card! Remember to consider the space around your design. Calligraphy needs room to breath and can look very cramped if the card is cut to closely.

This Noël was used as part of a Christmas card design.

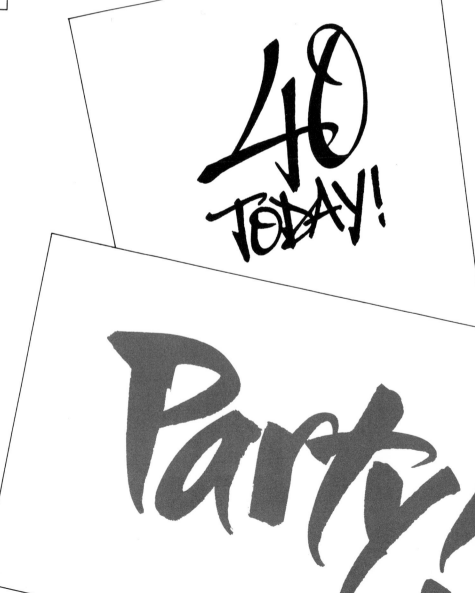

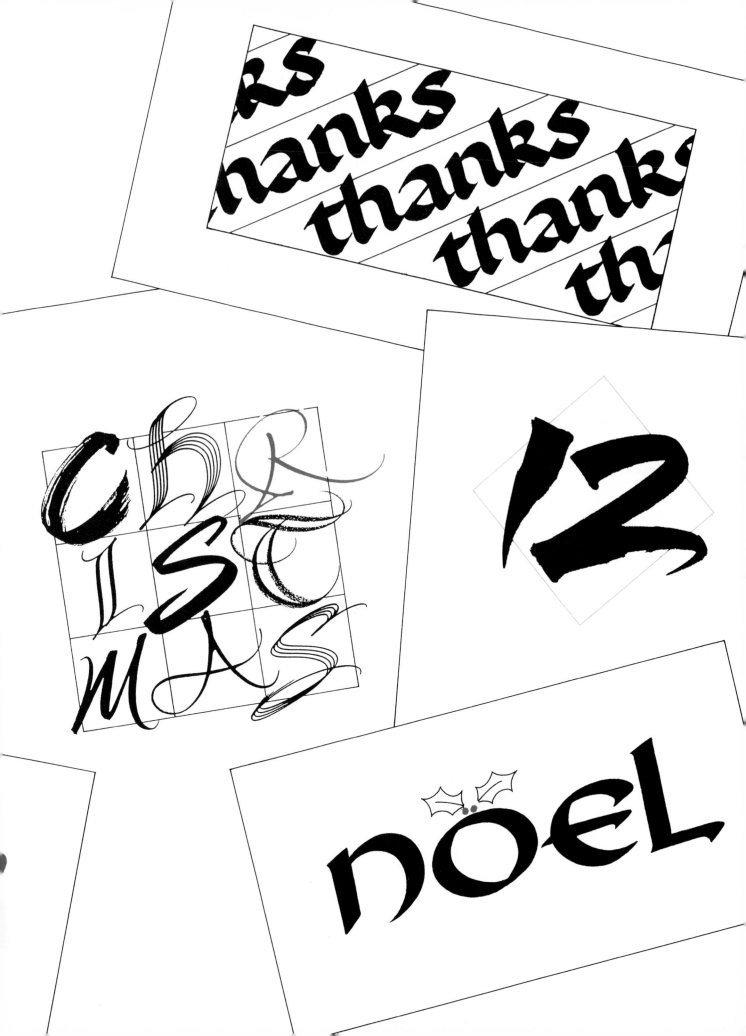

Making labels

Making labels is fun and simple to do. They can transform an everyday object into something special, especially if you make a matching set like those shown on the herb and spice jars below. You could cover a pencil jar with your own calligraphic patterned paper and stick a name label on the side. You can also cover books in this way. Try to match the style of lettering to the label's use. Look at the diary on the right. The free script letters are in keeping with a handwritten diary.

Write your letters on thick paper first, then cut out the label. This way you will not have to worry about centring the word. You can either glue the label to the object or attach it with double-sided tape.

Lettering used for the labels of Sunsilk hair care products.

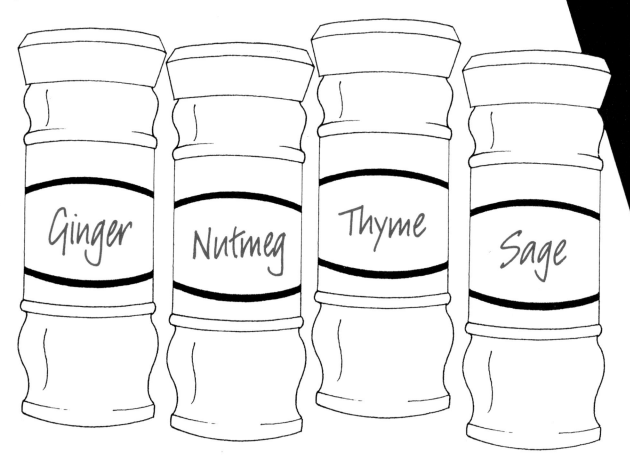

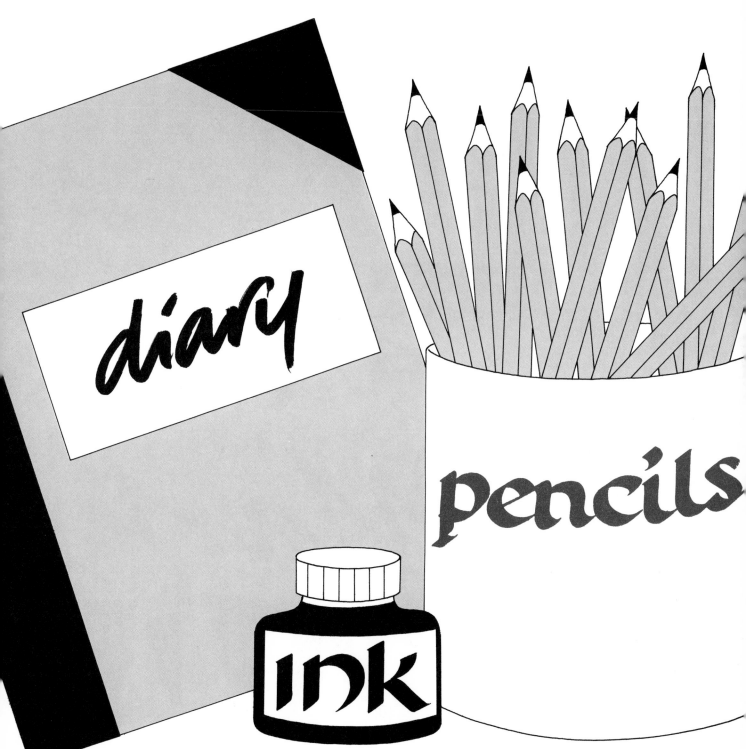

diary

pencils

ink

Making book plates

Label your books with attractive calligraphic labels, known as book plates. Book plates can be as simple or as complicated as you want. The label could just show your name, or you could use some words to say the book belongs to you. Some book plates use the Latin phrase *Ex Libris*, which means 'from the library of'. You could frame the words with a ruled line or a pattern as a decorative border. You could even include a little illustration.

Look at the names shown here. Choose one of these calligraphic styles or make up a different one to use for your own name.

The book plate will need to be planned carefully. You should consider the size of the label and the layout of the words. Draw some lines to write on and practise first until you are happy with the result. Use a photocopier to make copies, ready to stick into all your books.

Free-script written with an automatic pen

Free-script written with a brushline felt pen

Free capital letters written with a paint brush

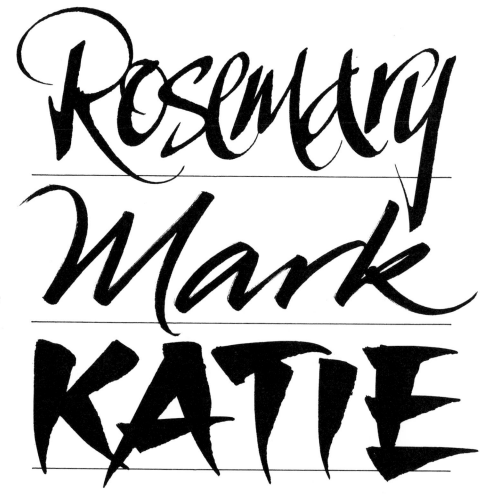

48

Anne

Roundhand written with a split-nib automatic pen

Christopher

Black letter script

Elizabeth

Italic script

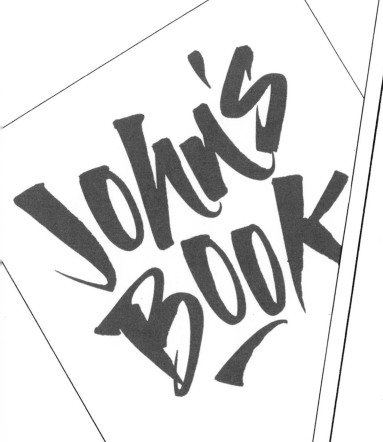

John's Book

This Book Belongs to Iain

Using capital letters

Use capital letters to get a wide variety of interesting effects. Capital letters often look very plain and simple. They are actually quite difficult to write or draw! Over the page you will see examples of classic Roman capitals which have a clean and elegant appearance. The simple lines of these and other styles make an ideal contrast to freely drawn letters. You can use them effectively in all the projects in this book.

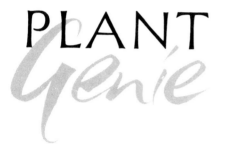

This logo for a company which supplies plants to offices and hotels uses capital letters and brush script.

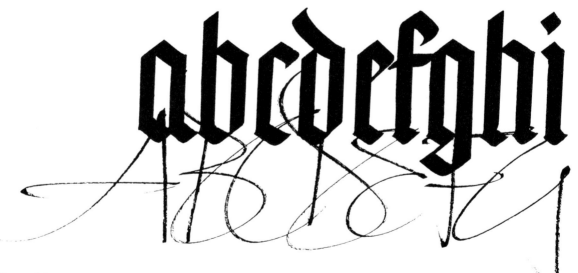

Uncial and free script

Black letter and free script

Italic and free script

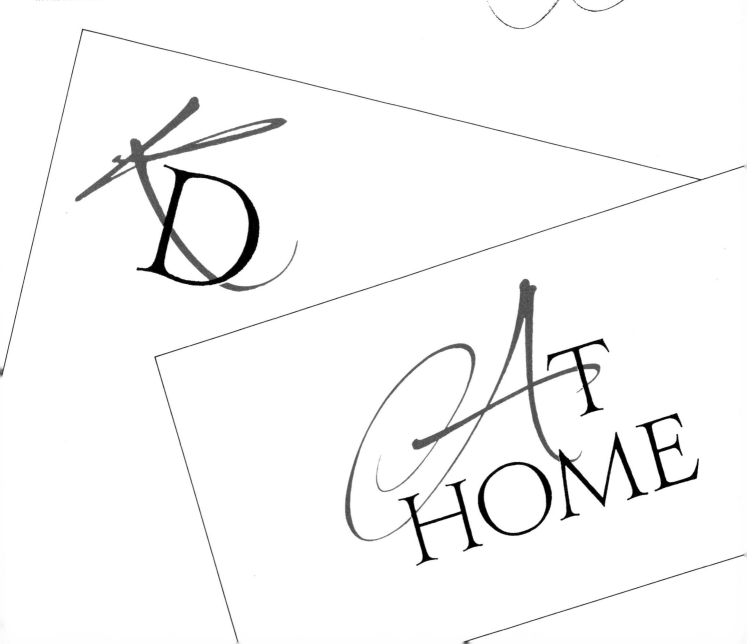

Below, KD monogram and At Home invitation card

ABCDE

abcdefg

KD

AT
HOME

Roman letters and skeleton capitals

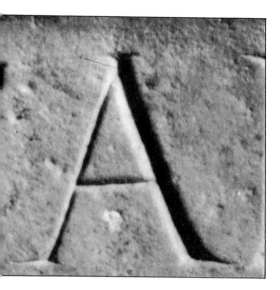

This Roman capital, carved in marble, dates from the 2nd century.

Any alphabet can be broken down into a basic line or skeleton form. This shows very simply how the letters are drawn. Capital letters from Roman times are based on a simple plan of a circle placed within a square.

The alphabet can be divided into wide, medium and narrow letters – see opposite. These simple rules are worth learning, but remember that rules are made to be broken! Make slight changes to some of the letters to improve the way they look. For example, the centre bars of the A and F should be lowered a little and those of the B, E and H raised. Letters with diagonal lines like K, M, R, W, X and Y can extend a little beyond the lines of the square.

ABCDEF
GHIJKL
MNOPQ
RSTUV
WXYZ

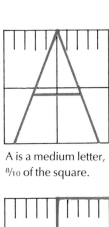

A is a medium letter, $^8/_{10}$ of the square.

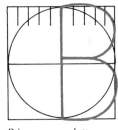

B is a narrow letter, $^1/_2$ of the square.

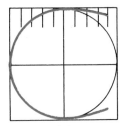

C is a wide letter, $^9/_{10}$ of the square.

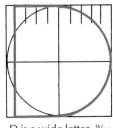

D is a wide letter, $^9/_{10}$ of the square.

E is a narrow letter, $^1/_2$ of the square.

F is a narrow letter, $^1/_2$ of the square.

G is a wide letter, $^9/_{10}$ of a square.

H is a medium letter, $^8/_{10}$ of the square.

I and J are narrow letters.

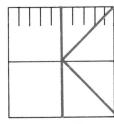

K is a narrow letter, $^1/_2$ of the square.

L is a narrow letter, $^1/_2$ of the square.

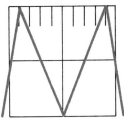

M is a wide letter, full square.

N is a medium letter, $^8/_{10}$ of the square.

O is a wide letter, full square.

P is a narrow letter, $^1/_2$ of a square.

Q is a wide letter, full square.

R is a narrow letter, $^1/_2$ of the square.

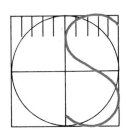

S is a narrow letter, $^1/_2$ of the square.

T is a medium letter, $^8/_{10}$ of the square.

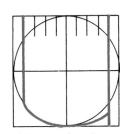

U is a medium letter, $^8/_{10}$ of the square.

V is a medium letter, $^8/_{10}$ of the square.

W is a wide letter, full square.

X is a narrow letter, $^1/_2$ of the square.

Y is a narrow letter, $^1/_2$ of the square.

Z is a medium letter, $^8/_{10}$ of the square.

A look at typefaces

Part of a column from Gutenberg's 42-line bible.

Until the 15th century, all books were handwritten by scribes. This was a very slow process. The first printing press was set up in Germany by Johann Gutenberg in 1450. The first type designs used in printing were based on the handwriting of the time. Johann Gutenberg made black letter script into the typeface used in his 42-line Bible printed between 1452 and 1456.

Today there are hundreds of different typefaces, some of which date back to the early 16th century. Most of them can be divided into three simple kinds:

Serif is the name given to letters which have a serif or 'foot' at the end of each stroke. Serifs can be triangular or oblong in shape.

Sans-serif is the name given to letters without serifs. These typefaces usually have very little contrast between the thick and thin strokes.

Script is the name given to letters based on a script or style of handwriting.

Some typefaces are drawn in a variety of weights. Helvetica, (right) is one. Illustrated here are light and medium

Bold and italic

Condensed and extended

54

ABCDE
abcde

Baskerville
This typeface has triangular shaped serifs.

ABCDE
abcde

Bodoni
The serifs here are thin and oblong. This is called 'hairline'. Note the big difference between the thick and thin strokes.

ABCDE
abcde

Rockwell
This typeface also has oblong serifs. Here they are much thicker than Bodoni and are known as slab-serifs. The letter strokes are of even thickness.

ABCDE
abcde

Helvetica
This is a sans-serif typeface.

Glossary

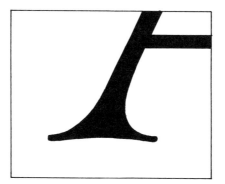

SERIF
The 'foot' at the end of a letter stroke.

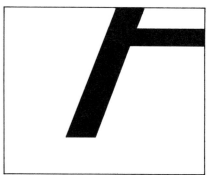

SANS-SERIF
A typeface which has no serifs.

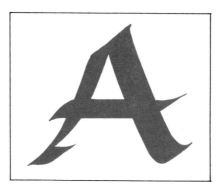

UPPER-CASE
Capital letters.

LOWER-CASE
Small letters.

ASCENCER
The upward tail of a letter.

DESCENDER
The downward tail of a letter.

X-HEIGHT
The height of letters without ascenders or descenders.

COUNTER
The space inside a letter.

CONDENSED
Letters which are tall and narrow.

EXTENDED
Letters which are flat and oblong.

CURSIVE
A running script.

INITIAL
A large capital letter at the beginning of a piece of writing or word.

LOGO
A trademark often for a company name. Usually a group of letters or a word written in a distinctive style.

ITALIC
Letters which are oval in shape and slanted to the right. This term is used for calligraphic letters and for typefaces.

LINE WEIGHT
A term used to describe the thickness of a letter stroke.

CONSTANT STROKE WIDTH
This refers to the even thickness of each letter stroke achieved by holding the pen at the same angle as you write.

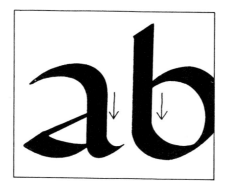

DOWN STROKE
The arrows above show the downstroke of the letters.

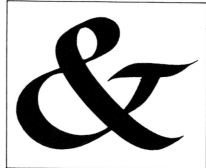

AMPERSAND
The sign used for the word 'and'. Useful if there is not enough room to write out the word.

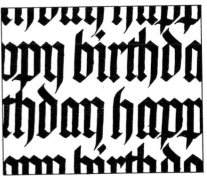

COLLAGE

A design made out of pieces of material such as paper which are then pasted down.

MANUSCRIPT

The name given to handwritten text, often for a book.

BLEED

A term used to describe the way ink spreads when used on blotting, or other porous paper. It also refers to a design which spreads off the page, leaving no margin.

TEXTURE

A word used to describe the surface of something, eg, rough, smooth. Letters written on watercolour paper have a rough texture.

Index